By looking at art with children, you can help them develop their innate capacities for careful observation and creative imagination. Each picture in *Places* contains a defined setting. In addition, each features such elements as people, activities, particular times of day, seasons, and weather. Children can begin by naming different things they see. You can ask them how they recognize these things, and how each thing might relate to their own lives. You can also lead children to see more elements in each picture, and encourage them to imagine stories based on what their eyes tell them. There are notes at the back of the book to help.

Enjoy looking together!

Places

Philip Yenawine

Places

The Museum of Modern Art, New York

Permissions and copyright notices:
Pages 1, 6, 10: © 2006 Artists Rights Society (ARS), New York / ADAGP, Paris
Page 9: © 2006 Artists Rights Society (ARS), New York
Page 14: © 2006 The Munch Museum / The Munch-Ellingsen Group / Artists Rights Society (ARS), New York
Page 19: © Estate of André Kertész
Page 20: © Berenice Abbott
Page 21: © 2006 Mondrian / Holtzman Trust, c/o Beeldrecht / Artists Rights Society (ARS), New York

Second edition 1999
Third edition 2006

Library of Congress Control Number: 92011202
ISBN: 978-0-87070-173-3

Published by The Museum of Modern Art
11 West 53 Street
New York, New York 10019
(www.moma.org)

Distributed in the United States and Canada by D.A.P., Distributed Art Publishers, Inc., New York

Distributed outside the United States and Canada by Thames & Hudson Ltd., London

Front cover: Detail of Edward Hopper, *Gas*. 1940.
Oil on canvas, 26 $1/4$ x 40 $1/4$" (66.7 x 102.2 cm).
Mrs. Simon Guggenheim Fund

Back cover: Detail of Ben Shahn, *Baseball*. 1939.
Tempera on paper over composition board, 22 $3/4$ x 31 $1/4$" (57.8 x 79.4 cm).
Abby Aldrich Rockefeller Fund

Printed in China

Looking at pictures, you can imagine practically any place.

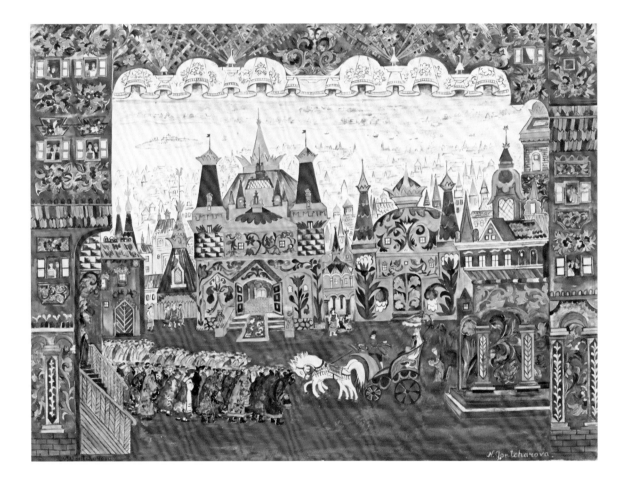

Natalia Goncharova. *The City Square*, décor for *Le Coq d'or*

You can visit a town...

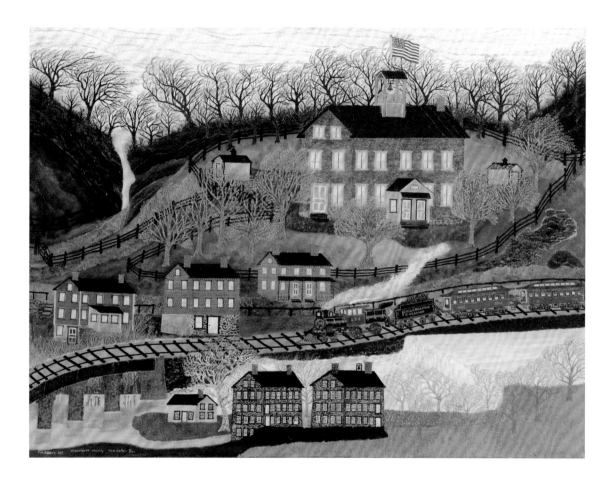

Joseph Pickett. *Manchester Valley*

or look around a farm.

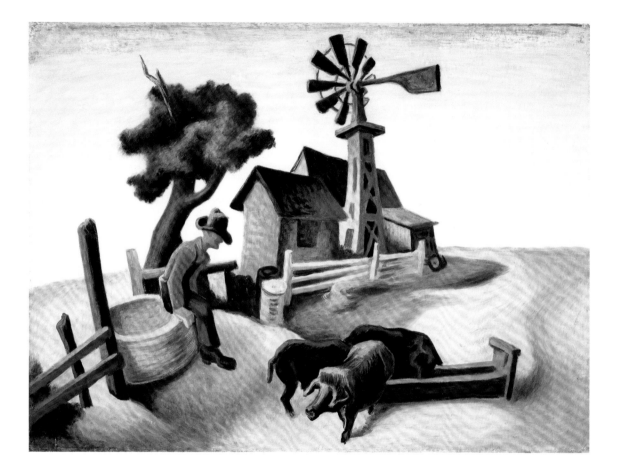

Thomas Hart Benton. *Homestead*

You can see yourself working...

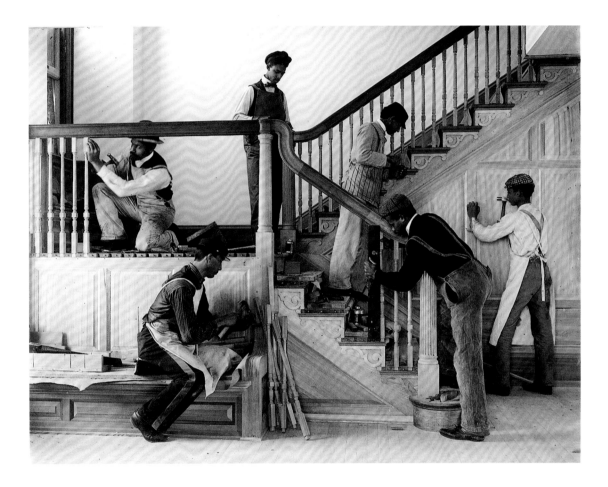

Frances Benjamin Johnston. *Stairway of the Treasurer's Residence: Students at Work*

or playing. Which boys are playing and which are watching? Can you tell where they are?

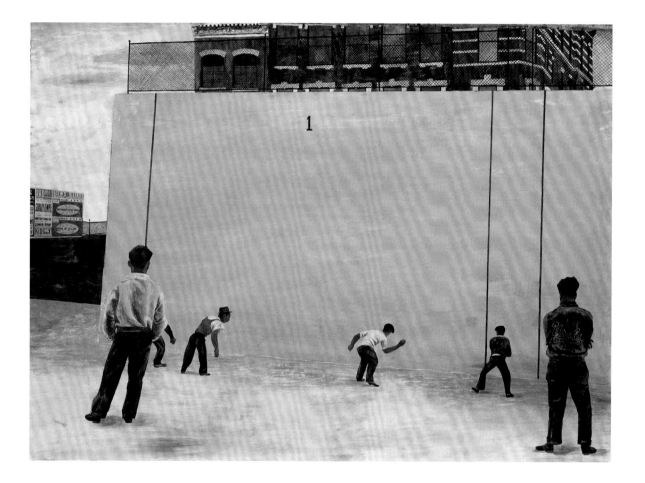

Ben Shahn. *Handball*

Is this place in a city? How can you tell? What time of the year do you think it is?

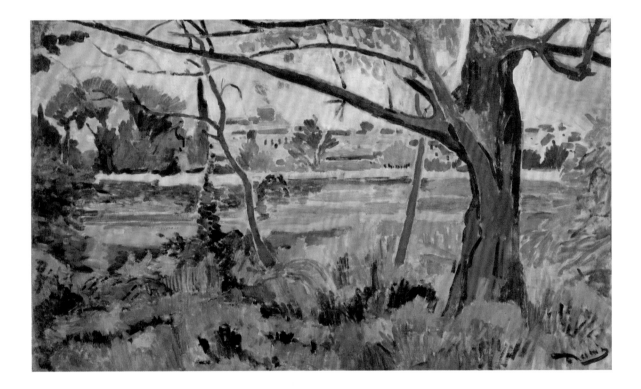

André Derain. *The Seine at Chatou*

How can you tell where this man is?

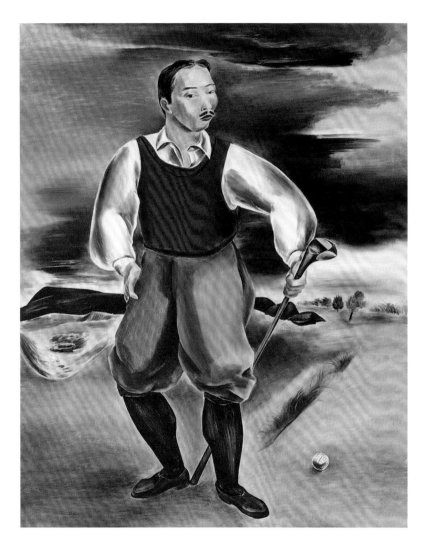

Yasuo Kuniyoshi. *Self-Portrait as a Golf Player*

Can you imagine being inside this room, dressed up and feeling very fancy?

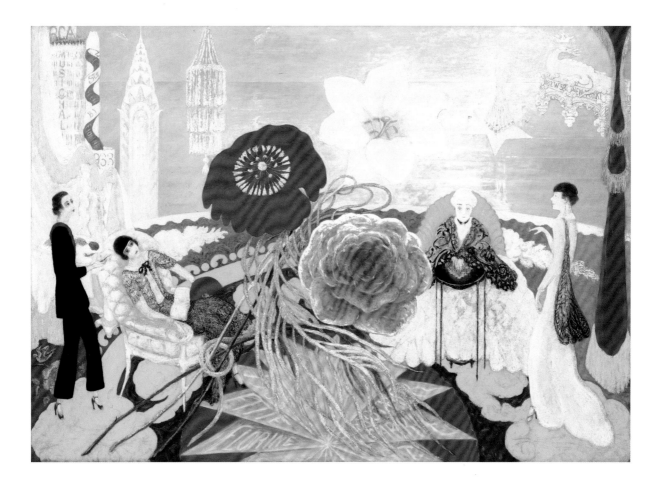

Florine Stettheimer. *Family Portrait, II*

Here is a very different kind of room. Can you describe it? What is happening here?

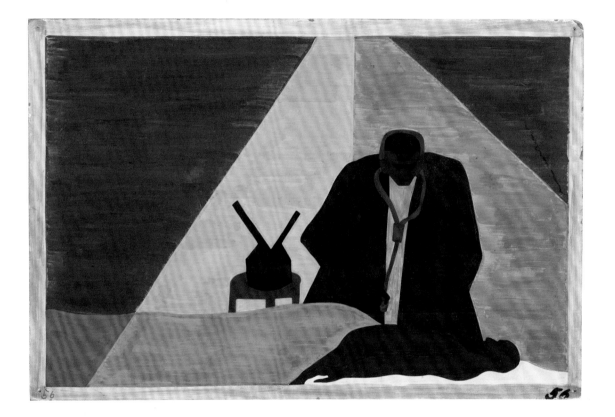

Jacob Lawrence. *Among one of the last groups to leave the South was the Negro professional who was forced to follow his clientele to make a living*

Pictures can let you look through windows. What do you see outside?

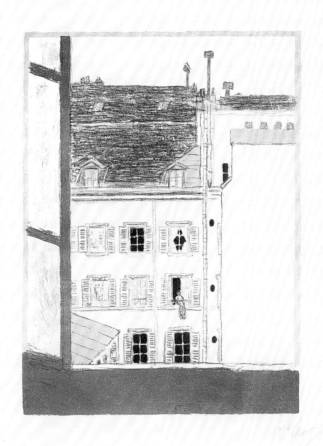

Pierre Bonnard. *House in a Courtyard,* from the portfolio *Some Scenes of Parisian Life*

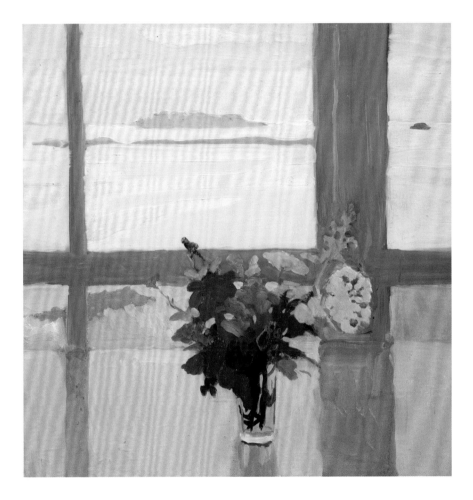

Fairfield Porter. *Flowers by the Sea*

What do you think this woman sees outside her window?

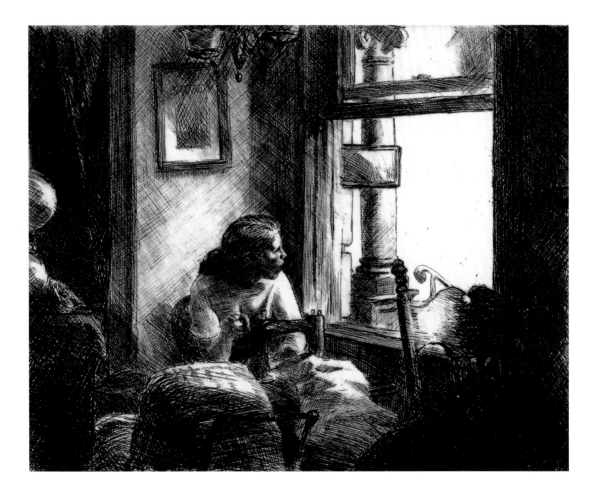

Edward Hopper. *East Side Interior*

Might she see a place like this?

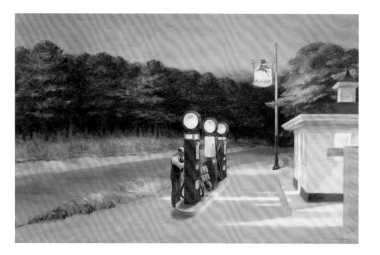

or this? Why do you think so?

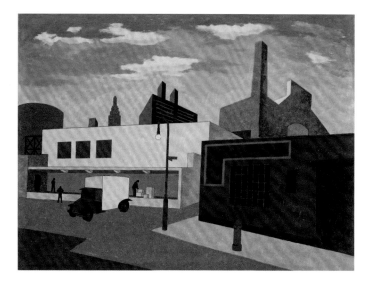

Edward Hopper. *Gas;* Niles Spencer. *Near Avenue A*

Pictures can make you think of stormy nights... of the rain and wind in your face.

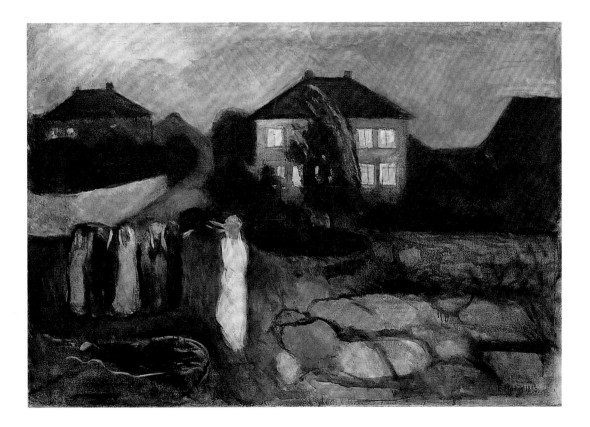

Edvard Munch. *The Storm*

In pictures, you can visit strange houses.

What is happening in this place?

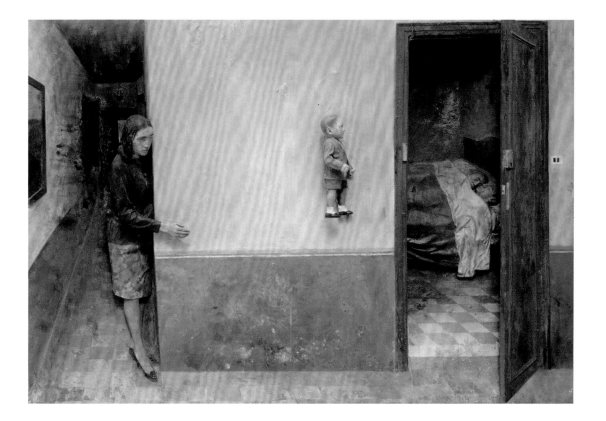

Antonio López García. *The Apparition*

Imagine a world where bugs are huge.

Find butterflies and moths and other creatures you may never have seen before.

Can you find flowers, clouds, rocks, and water?

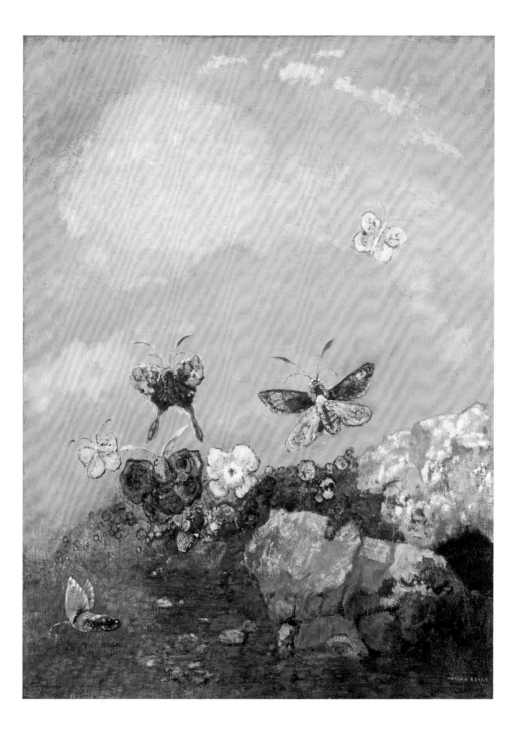

Odilon Redon. *Butterflies*

Pictures can let you look up into trees, as mice might...

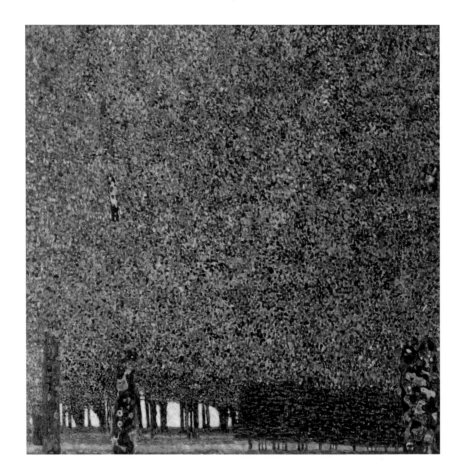

Gustav Klimt. *The Park*

or look down on people, shadows, and train tracks, as birds can.

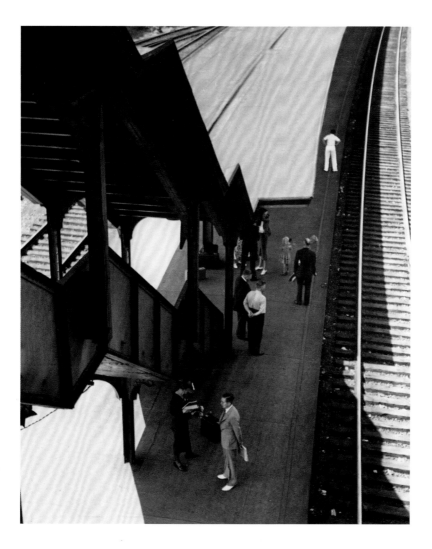

André Kertész. *Railroad Station*

If you flew above the city at night, it might look like a pattern of light.

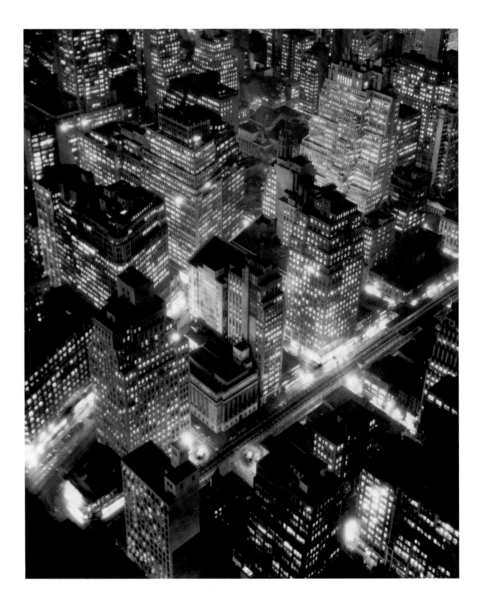

Berenice Abbott. *New York at Night*

Here's another pattern.

Can you imagine city blocks? streets? cars?

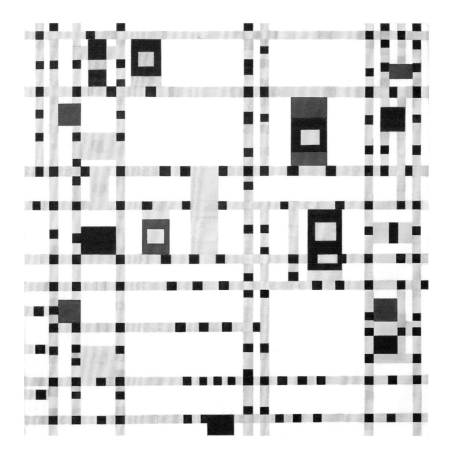

Piet Mondrian. *Broadway Boogie Woogie*

Looking and imagining can help you think of things to draw. Can you draw what you see from your window? Can you draw the country and the city? places for work and play? real and made-up places? What other kinds of places can you think of?

The art in this book is in the collection of The Museum of Modern Art in New York City, but you can find interesting pictures at any museum or gallery. You can also look for pictures and patterns in magazines, books, buildings, parks, and gardens.

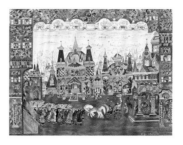

Page 1
Natalia Goncharova
The City Square, décor for *Le Coq d'or*. c. 1937
Gouache, watercolor, and pencil on board
18 ³/₈ x 24 ¹/₂" (46.7 x 61.6 cm)
Acquired through the Lillie P. Bliss Bequest

There are dozens of details in this fanciful, colorful set design. Looking in windows and doors, finding animals, boats, flags, towers, and flowers is a great way to open a child's eyes.

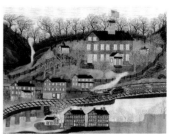

Page 2
Joseph Pickett
Manchester Valley. 1914–18?
Oil with sand on canvas
45 ¹/₂ x 60 ⁵/₈" (115.4 x 153.7 cm)
Gift of Abby Aldrich Rockefeller

This work by a self-taught artist has a simplicity that often appeals to children. Ask children to take an inventory of what's included in the picture, and ask them about the season and the weather.

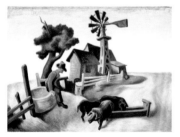

Page 3
Thomas Hart Benton
Homestead. 1934
Tempera and oil on composition board
25 x 34" (63.5 x 86.4 cm)
Gift of Marshall Field (by exchange)

Benton is a master at depicting the American scene. Consider what the farmer might be doing at this moment. How about the pigs? Ask what might lie beyond the buildings.

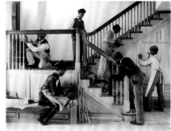

Page 4
Frances Benjamin Johnston
Stairway of the Treasurer's Residence: Students at Work. 1899–1900
Platinum print
7 ¹/₂ x 9 ¹/₂" (19.1 x 24.1 cm)
Gift of Lincoln Kirstein

Though the six men pictured are hard at work, they seem to be posing. The angles of their bodies echo the stairway's structure, emphasizing lines and patterns as much as the activity depicted.

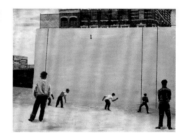

Page 5
Ben Shahn
Handball. 1939
Tempera on paper over composition board
22 ³/₄ x 31 ¹/₄" (57.8 x 79.4 cm)
Abby Aldrich Rockefeller Fund

This picture seems less static than the last one. Children will have to look beyond the court to determine the location of this handball game. What about the season and weather?

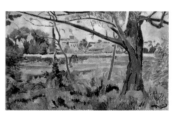

Page 6
André Derain
The Seine at Chatou. 1906
Oil on canvas
29 ¹/₈ x 48 ³/₄" (74 x 123.8 cm)
The William S. Paley Collection

We seem to be standing on a grassy riverbank, looking across the calm waters toward a town. The colors of a bright summer day are especially intense. The bare branches of the tree and saplings conveniently frame our view.

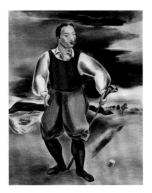

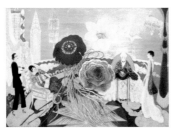

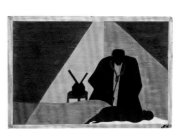

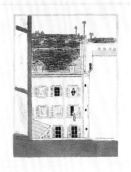

Page 7
Yasuo Kuniyoshi
Self-Portrait as a Golf Player. 1927
Oil on canvas
50 ¼ x 40 ¼" (127.6 x 102.2 cm)
Abby Aldrich Rockefeller Fund

Like Johnston's photograph, Kuniyoshi's self-portrait catches a figure frozen in action. He seems to be posing, rather than playing golf. Look beyond the figure to the landscape and sky. Think about why the artist might have chosen to represent himself in this way.

Page 8
Florine Stettheimer
Family Portrait, II. 1933
Oil on canvas
46 ¼ x 64 ⅝" (117.4 x 164 cm)
Gift of Miss Ettie Stettheimer

Despite overly large flowers that partially block our view, we can still see into a grand room in which there are four elegantly dressed women. You might point out the artist herself on the left, complete with palette, brushes, and high heels.

Page 9
Jacob Lawrence
Among one of the last groups to leave the South was the Negro professional who was forced to follow his clientele to make a living. 1940-41
Tempera on gesso on composition board
12 x 18" (30.5 x 45.7 cm)
Gift of Mrs. David M. Levy

Omitting most details, Lawrence shows a doctor at a patient's bedside, with his stethoscope and bag. He is framed within a triangle, which might represent the light from an unseen bulb overhead. The vertical division of the triangle may suggest the corner of a spare, darkened room. Look for differences between the rooms and people in this image and the one before.

Page 10
Pierre Bonnard
House in a Courtyard, from the portfolio *Some Scenes of Parisian Life*. 1895
Lithograph
Composition: 13 ¹¹⁄₁₆ x 10 ¼"
(34.7 x 26 cm); sheet: 20 ¹⁵⁄₁₆ x 15 ¹⁵⁄₁₆"
(53 x 40.6 cm)
Larry Aldrich Fund (by exchange)

We see buildings, windows, and other architectural details here, but this image, framed by the window, might seem as much a design as a realistic depiction of a scene.

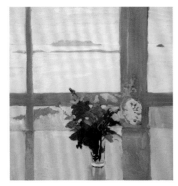

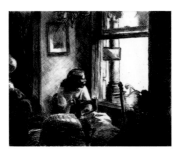

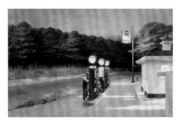

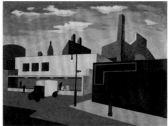

Page 11
Fairfield Porter
Flowers by the Sea. 1965
Oil on composition board
20 x 19 ½" (50.6 x 49.5 cm)
Larry Aldrich Foundation Fund

The vertical and horizontal lines of the windows and their reflections on the tabletop create a sense of pattern, as in the Bonnard image. The vase of flowers and the suggestion of water and rocks evoke a pleasant sense of summer by the sea.

Page 12
Edward Hopper
East Side Interior. 1922
Etching, printed in black
Composition: 7 ⅞ x 9 ¹³⁄₁₆"
(20 x 25 cm); sheet: 13 ⁹⁄₁₆ x 16 ¾"
(34 x 42.6 cm)
Gift of Abby Aldrich Rockefeller

Sitting at her sewing machine, leaning forward, one hand on the wheel, this young woman has been caught by a reverie, or perhaps by something she sees. She is completely absorbed. Note the porch column and railing outside the window.

Page 13
Edward Hopper
Gas. 1940
Oil on canvas
26 ¼ x 40 ¼" (66.7 x 102.2 cm)
Mrs. Simon Guggenheim Fund

Is there any evidence in the preceding picture that the woman might be looking out on this rustic highway scene? Children can try to guess the season and time of day. What might the man be doing, dressed as he is?

Page 13
Niles Spencer
Near Avenue A. 1933
Oil on canvas
30 ¼ x 40 ¼" (76.8 x 102.2 cm)
Gift of Nelson A. Rockefeller

This picture includes many elements of a city. Let children name what they find, and ask them what they see that makes them think of a city. What activity might the young woman at the window (see page 12) be watching?

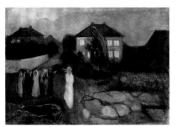

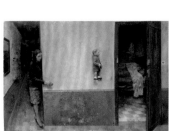

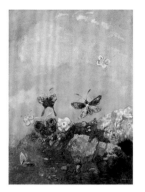

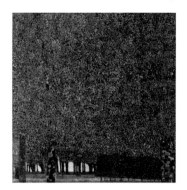

Page 14
Edvard Munch
The Storm. 1893
Oil on canvas
36 ¹/₈ x 51 ¹/₂" (91.8 x 130.8 cm)
Gift of Mr. and Mrs. H. Irgens Larsen and
acquired through the Lillie P. Bliss and
Abby Aldrich Rockefeller Funds

Munch is known for his somewhat
macabre pictures, and this ghostly scene
is typical. Time, weather, and location can
be figured out, but the identity of the peo-
ple and what they are doing are mysteries.

Page 15
Antonio López García
The Apparition. 1963
Oil on wood
21 ¹/₂ x 31 ⁵/₈ x 5 ³/₈"
(54.5 x 80.2 x 13.6 cm)
Gift of the Staempfli Gallery

This picture tells another mysterious story.
Who are the people? What kind of place
is this? Where does the strong light come
from? What might happen next?

Page 17
Odilon Redon
Butterflies. c. 1910
Oil on canvas
29 ¹/₈ x 21 ⁵/₈" (73.9 x 54.9 cm)
Gift of Mrs. Werner E. Josten in memory
of her husband

Redon's world is filled with views that
intensify ordinary experience, making it
seem magical. He also mixes the real and
the imaginary. These outsized figures may
appear as they do to small children.

Page 18
Gustav Klimt
The Park. 1910 or earlier
Oil on canvas
43 ¹/₂ x 43 ¹/₂" (110.4 x 110.4 cm)
Gertrud A. Mellon Fund

Well-dressed couples stroll beneath a
tremendous expanse of green. The foliage
is as much speckled color as it is a repre-
sentation of leaves. We again see an artist
giving equal importance to a subject, a
feeling, and a pattern.

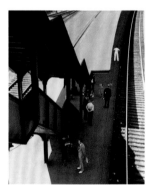

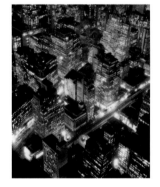

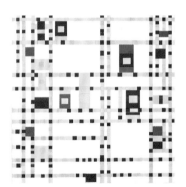

Page 19
André Kertész
Railroad Station. 1937
Gelatin silver print
9 ¹/₂ x 7 ⁵/₁₆" (24.1 x 18.6 cm)
Gift of the photographer

The previous work focused on pattern in
nature. Here, Kertész positioned his cam-
era in order to emphasize patterns found
in a city. Ask children what they think is
going on here, and see if they notice
shapes as well as structures.

Page 20
Berenice Abbott
New York at Night. 1933
Gelatin silver print
12 ⁷/₈ x 10 ⁹/₁₆" (32.7 x 26.9 cm)
Purchase

In this bird's-eye view, it may take a
moment for children to recognize build-
ings. By taking her picture at night,
Abbott eliminated much detail and repre-
sented the city as a pattern of light and
dark.

Page 21
Piet Mondrian
Broadway Boogie Woogie. 1942–43
Oil on canvas
50 x 50" (127 x 127 cm)
Given anonymously

Many pictures in this book reveal a fasci-
nation with lines and patterns. Here,
Mondrian has painted only lines and
squares of color that look as if they could
be a simple rendering of a city grid.
Naming it after a street and a jazz rhythm,
he probably intended to convey the spirit
of the city.